THIS NOTEBOOK BELONGS TO ..

CONTACT ..

See our range of fine, illustrated books, ebooks, notebooks and art calendars:
www.flametreepublishing.com

This is a **FLAME TREE NOTEBOOK**
Published and © copyright 2021 Flame Tree Publishing Ltd

FTNB 270 • ISBN: 978-1-78755-829-8

Royal
Botanic **Kew**
Gardens

Cover image based on a detail from
View in the Brisbane botanic garden
by Marianne North (1830–90)
© The Trustees of the Royal Botanic Gardens, Kew, 2021. www.kew.org

The Royal Botanic Gardens, Kew is a world-famous centre for botanical and mycological
knowledge. It has a gallery dedicated to the paintings of the remarkable Victorian artist
Marianne North, who had a great eye for botanical detail. She set out in 1871 on a painterly
progress through world flora. It was Charles Darwin who suggested North travel to Australia,
which she took as a 'royal command,' she arrived in Brisbane in 1880.

FLAME TREE PUBLISHING | The Art of Fine Gifts
6 Melbray Mews, London SW6 3NS, United Kingdom